BUGS IN CLOSE-UP

Colin Hutton

First published in 2014 by Reed New Holland Publishers Pty Ltd
London • Sydney • Auckland

The Chandlery, Unit 009, 50 Westminster Bridge Road, London SE1 7QY, United Kingdom
1/66 Gibbes Street, Chatswood, NSW 2067, Australia
218 Lake Road, Northcote, Auckland 0627, New Zealand

www.newhollandpublishers.com

Copyright © 2014 Reed New Holland Publishers Pty Ltd
Copyright © 2014 in text and images: Colin Hutton

All rights reserved. No part of this publication may be reproduced, stored in a retrieval system or transmitted, in any form or by any means, electronic, mechanical, photocopying, recording or otherwise, without the prior written permission of the publishers and copyright holders.

A record of this book is held at the British Library and the National Library of Australia.

ISBN 978 1 92151 738 9

Managing Director: Fiona Schultz
Publisher and Editor: Simon Papps
Designer: Thomas Casey
Production Director: Olga Dementiev
Printer: Toppan Leefung Printing Ltd

10 9 8 7 6 5 4 3 2 1

Keep up with New Holland Publishers on Facebook
www.facebook.com/NewHollandPublishers

BUGS IN CLOSE-UP

Colin Hutton

CONTENTS

Introduction	6
MOTHS AND BUTTERFLIES	**10**
Camouflage	26
Mimicry	31
Eye-spots	36
Prominent caterpillars	45
Slug caterpillars	47
Atala Butterfly	56
DRAGONFLIES AND DAMSELFLIES	**60**
Damselfly portraits	73
BEES AND WASPS	**76**
FLIES	**90**
BEETLES	**106**
Tortoise beetles	122
GRASSHOPPERS, KATYDIDS AND CRICKETS	**130**
Leaf mimic	144
Lichen mimic	146
Peacock katydid	148
MANTISES AND PHASMIDS	**150**
Hatching	169
TRUE BUGS	**168**
Leafhoppers	190
SPIDERS	**196**
MORE AMAZING BUGS	**218**
Mantisfly	230
Dobsonfly	232
Macro	**234**
Acknowledgments	**237**
Further reading	**237**
Image details	**237**
Index	**238**

INTRODUCTION

Bugs get a bad rap. Even the word 'bug' has been co-opted to describe the act of being unwanted and bothersome. Millions of insects are squashed under shoes and rolled-up newspapers every day. A bounty of sprays, poisons, and traps exist for the sole purpose of killing bugs. An entire industry is devoted to removing bugs from homes and yards. Countless hours and dollars are committed to the pursuit of ridding our lives of bugs. And yet… bugs are awesome.

For starters, many bugs perform roles that benefit humans and the environment. The most obvious example is the pollinators, without which many of the Earth's plants, including most crops, would not be able to produce seeds. Although bees are the most recognized pollinators, numerous other insects including many wasps, butterflies, and flies also fulfill this role. Another major contribution many bugs make is through pest control. True, many of the pests are bugs themselves, but for many pests, predatory and parasitic bugs are the primary agents keeping their populations is check. Bugs also provide a food source for numerous creatures, including many that eat nothing else. Even certain human cultures consume insects.

Regardless of their benefits to people, the most amazing aspects of bugs are their appearance, behaviour and life histories. Bugs run the gamut from beautiful to bizarre, with some exhibiting a bit of both. Butterflies are an obvious example of beautiful bugs, but all the orders of insects contain colourful species. The bright, iridescent blues, greens, and purples of tiger beetles make them appear as tiny jewels as they race across sand dunes and mud flats. Some leaf beetles have exoskeletons that shimmer with all the colours of the rainbow. Tiny, easily overlooked leafhoppers have just as much colour and diversity as the small tropical fish inhabiting a coral reef. Even spiders come in bright colours with shiny blue fangs.

Bugs can appear very strange, with many looking more like aliens than inhabitants of Earth. With their bulging eyes and triangular heads, praying mantises and toadbugs have faces very reminiscent of an extraterrestrial. Dragonfly and damselfly larvae even have a second mouth that shoots out from inside their main mouth, much like the creature in the *Alien* movies. An almost perfect copy of an amblypygid makes an appearance in the *Harry Potter and the Goblet of Fire* film, and the creatures from the movie *District 9* were partly inspired by images of katydids.

The unique appearance of many bugs is often the result of the need to avoid being eaten by predators. Most bugs are quite small and are preyed upon by a variety of creatures. As a result, many bugs have extremely effective camouflage and look more like ambulatory sticks and leaves than bugs.

Katydids have turned leaf mimicry into an art form, with different species replicating minute details of leaves including everything from the fine venation, wavy shape and gnarled edges to the tiny bits of surface debris. Stick insects are well known for their resemblance to twigs, but some also look like lichen or clumps of moss, not just by having the same colour pattern, but by being covered in small projections that resemble tendrils of moss. Many treehoppers have thorns which resemble those of the trees on which they feed.

Many bugs don't mimic their environment, but instead resemble other species of bugs which are toxic or venomous. Harmless katydids will mimic ants and spiders; flies, butterflies, and moths mimic bees and wasps; spiders and praying mantises mimic ants; leafhoppers mimic wasps, and so on. The strategy is so effective that hundreds, if not thousands, of bugs engage in it. Sometimes, the mimicry is so convincing that the deception is only revealed when looking through a macro lens.

Appearance is only part of bugs' appeal, for bugs also have some of the most interesting behaviours in the animal kingdom. Some male jumping spiders have elaborate courtship displays that involve performing charming dances for female observers. Some silk moths and katydids flash open their wings when approached by a predator to reveal large eye-spots that give the appearance of staring into the face of an owl. Orchid bees rub chemicals on their bodies that attract females. Fishing spiders carry a bubble of air underwater so that they can breathe as they hunt for fish.

The life histories of insects have no comparison among the vertebrates. Whereas young vertebrates resemble miniature adults, most insects look nothing like adults. They often live in completely different habitats and consume different food. Take dragonflies, for example. The adults are winged predators feeding mostly on small flying insects, which they chase down. The nymphs are flightless aquatic organisms that ambush small fish and other tiny aquatic creatures.

The beauty, singularity and variety of bugs is amazing. Perhaps the reason they are so maligned stems from the fact most people don't really know what they look like. From a distance bugs can appear to be faceless masses of too many legs. While some may be homely or frightening up close, more often than not they're interesting, visually appealing, and even charming. Many of them even have quite expressive faces. They probably don't actually have emotions or personalities, but it's difficult not to anthropomorphize some bugs when viewing their portraits. Most bugs' small size prevents us from seeing this side of them with the naked eye. However, a macro lens opens up a whole new word of wondrous beings that are all around us, yet frequently go unnoticed.

This book gives readers a chance to see this hidden world by revealing the true face of bugs. Some of the images presented here show bugs that live deep within tropical forests, but the majority depict common creatures that can be found in backyards. Some are quite large and can be appreciated without the aid of a macro lens, while others are only a few millimetres long and just identifying the order they belong to can be challenging without the help of high magnification optics. Regardless of size, most of these creatures are rarely noticed when people pass by, and if they are, the reaction is usually either apathy or fear. If the human eye functioned as a macro lens, perhaps these same bugs would be met with feelings of awe and fascination. Since it doesn't, we must rely on macro photography to glimpse the hidden, awesome world of bugs.

INTRODUCTION // 9

MOTHS AND BUTTERFLIES

BUTTERFLIES AND MOTHS form the order Lepidoptera, perhaps the one order of insects that most people like. Their beautiful wings and the fact that they are harmless to humans make it hard to dislike these insects. Moths and butterflies are similar in appearance, but the antennae can usually differentiate the two. Butterflies have long, slender antennae with clubbed ends, while moth antennae are more feathery, especially on the males. This distinction is hard to see from a distance, so the easiest way to separate the two is by the time of day they are active. Most moths come out at night (with some exceptions), while butterflies are active during the day.

Even though most people understand that butterflies and moths begin life as caterpillars, caterpillars are often seen as a different, less desirable creature. Caterpillars don't have beautiful wings, but they do come in spectacular colours and their appearance is far more diverse and strange than the butterflies and moths they become. Being slow-moving, flightless, and exposed, caterpillars can be easy meals for predators, so many have evolved elaborate camouflage and other defences resulting in truly bizarre organisms.

Staking out flowers is one of the best ways to photograph butterflies. They tend to be less concerned about approaching humans while they are in the middle of feeding. Areas with numerous flowers and higher human traffic can be great places for seeking images, because the butterflies are more accustomed to people being nearby. For this reason, botanical gardens are a great place to hunt for butterflies. Except for a few species of diurnal moths, bright lights are also an excellent place to look for moths at night. Moths may even hang around these sites during the day. Caterpillars are also much easier to find at night. They are usually more active and a headlamp makes it easier to distinguish even well-camouflaged caterpillars from their surroundings. Luckily, learning where – and when – to look makes photographing these beautiful and elusive creatures a less daunting challenge.

PREVIOUS PAGES
Cloudless Sulphur *Phoebis sennae*

Butterflies have a long proboscis which they use to suck nectar from flowers. When not feeding, the proboscis coils up into a small bundle.

OPPOSITE
Luna Moth *Actias luna*

Most photographs taken of moths and butterflies tend to focus on the wings, but many of these beautiful insects also have interesting faces. Male giant silk moths, like this Luna Moth, have very large and feathery antennae for homing in on the pheromones emitted by females.

PAGE 14
Polyphemus Moth
Antheraea polyphemus

Caterpillars have two types of legs: true segmented legs near the head, and several pairs of fleshy prolegs, which are pictured here. The prolegs are thicker than the true legs and keep a firm grip on the caterpillar's perch.

PAGE 15
Polyphemus Moth
Antheraea polyphemus

While butterflies and moths are widely regarded as beautiful creatures, their larvae are much less popular. The process of a caterpillar turning into a butterfly is employed as a metaphor for a transition from something ugly into something beautiful, yet caterpillars are among the most amazing creatures a macro photographer can hope to find. This large Polyphemus caterpillar is a perfect example. The texture and tone of its skin makes it appear as if the caterpillar is glowing.

14 // BUGS IN CLOSE-UP

PREVIOUS PAGES
Black Swallowtail *Papilio polyxenes*

Caterpillars are slow-moving and flightless, making them ideal prey for a hungry predator. Because of their vulnerability, many caterpillars have developed defences to ward off attack. Swallowtail caterpillars can project fleshy, brightly coloured horns from atop their heads. These horns emit a very pungent odour which deters predators.

OPPOSITE
Eighty-eight Butterfly *Diaethria anna*

The numbers are so distinct that it looks like a photo-editing trick, but the pattern on this little beauty's wings is a design of nature.

ABOVE
Spotted Datana *Datana perspicua*

Datana caterpillars are social and can often be found in large groups, especially when they're younger. They feed in a large mass and when they feel threatened all the individuals rear up in the defensive pose pictured here. They also secrete a foul-tasting liquid to deter predators.

ABOVE
Waved Sphinx *Ceratomia undulosa*

Most caterpillars are shades of green or brown to better blend in with their environment, but coloration can vary greatly, even within a species. Most Waved Sphinx caterpillars are green, but this rare individual is bright red. Being so conspicuously coloured for its environment, it is lucky not to have been spotted and eaten by a predator prior to reaching adulthood.

OPPOSITE
Walnut Sphinx *Amorpha juglandis*

Hornworms get their name from the spike near the rear of the caterpillar. Some species thrash their horn about when threatened by a predator, but the fierce display is misleading. While the horn appears very sharp, it is actually completely harmless and non-venomous.

PAGE 22
Hickory Horned Devil *Citheronia regalis*

At 15 centimetres in length, the Hickory Horned Devil is one of the largest caterpillars in North America. With its rows of fearsome spines, this insect is also one of the most intimidating-looking species. Despite the name and scary appearance, these caterpillars are harmless and can be safely handled.

PAGE 23
Inch worm Geometridae

These caterpillars are often called inch worms due to their unique method of locomotion. Unlike most other caterpillars, they only have two pairs of prolegs located at the very rear of the caterpillar. Their slender form allows many species to disguise themselves as sticks, but this species exhibits rather unusual coloration.

MOTHS AND BUTTERFLIES // 21

22 // BUGS IN CLOSE-UP

MOTHS AND BUTTERFLIES // 25

LEFT
Black Swallowtail
Papilio polyxenes asterius

Moth and butterflies are covered in tiny scales. The coloured scales give butterflies their beautiful appearance. Those who have handled butterflies may have noticed dust on their hands. This is actually the tiny, delicate scales that have rubbed off.

ABOVE
White-dotted Prominent
Nadata gibbosa

This caterpillar may look like an easy meal, but it doesn't go down without a fight. When threatened, it curls up like a snake and flashes its gaping mandibles at the attacker. If the predator persists, the caterpillar will attempt to nip the threat.

CAMOUFLAGE

Moths, butterflies, and their larvae can be masters of disguise. Many species of moth and butterfly have wings that strongly resemble leaves. The Dot-lined White caterpillar is camouflaged like a twig and even has feathery edges that wrap around the stick to create a smooth profile. Many geometrids look exactly like small sticks while others actually nip off plant parts and attach them to their bodies. Still other caterpillars have strange projections that help them blend in with moss-covered vegetation.

ABOVE LEFT
Unidentified butterfly Lepidoptera

ABOVE RIGHT
Brown-shaded Gray Moth
Iridopsis defectaria

OPPOSITE TOP
Curve-lined Owlet
Phyprosopus callitrichoides

OPPOSITE BOTTOM
Brush-footed Butterfly Adelpha serpa

OVERLEAF
Wavy-lined Emerald Moth
Synchlora aerata

PAGE 30
Dot-lined White Artace cribraria

MIMICRY

Butterflies, moths, and caterpillars are usually quite harmless and can make easy meals for other animals. Some caterpillars try to appear less appetizing to predators by mimicking bird droppings. The Harris's Three Spot even retains its head capsules from previous moults to add to the disguise. Adult moths sometimes mimic stinging insects like bees and wasps.

ABOVE LEFT
Snowberry Clearwing Hemaris diffinis

ABOVE RIGHT
Harris's Three Spot
Harrisimemna trisignata

OVERLEAF
Wasp mimic moth Myrmecopsis sp.

PAGE 34
Raspberry Crown Borer
Pennisetia marginata

PAGE 35
Giant Swallowtail Papilio cresphontes

32 // BUGS IN CLOSE-UP

MOTHS AND BUTTERFLIES // 33

34 // BUGS IN CLOSE-UP

EYE-SPOTS

Many species of moths and caterpillars have false eye-spots. On caterpillars these large spots are much larger than the caterpillar's actual eyes and may make the caterpillar seem more threatening to potential predators. On moths, the eye-spots are usually hidden while the moth is at rest. If a predator approaches too closely, the moth will swing open its wings to reveal two large eyes, which are presumably intended to startle the predator, or at least divert its aim away from the moth's body.

ABOVE
Eastern Tiger Swallowtail
Papilio glaucus

OPPOSITE
Spicebush Swallowtail *Papilio troilus*

OVERLEAF
Sphinx moth Sphingidae

PAGE 40
Saddleback moth
Acharia stimulea

PAGES 41–44
Silk moth Saturniidae

40 // BUGS IN CLOSE-UP

42 // BUGS IN CLOSE-UP

MOTHS AND BUTTERFLIES // 43

44 // BUGS IN CLOSE-UP

PROMINENT CATERPILLARS

The caterpillars of many prominent moths are camouflaged as the margins of the leaves that they feed on. The ridges on their backs and detailed patterns make these caterpillars extremely hard to see, even when they're actively feeding during the day.

ABOVE LEFT
Double-toothed Prominent
Nerice bidentata

PAGE 46
Black-blotched Prominent
Schizura leptinoides

ABOVE RIGHT
White-streaked Prominent
Oligocentria lignicolor

SLUG CATERPILLARS

While many caterpillars are harmless and use camouflage to avoid being eaten, slug caterpillars are brightly coloured and rely on venomous spines to keep them safe from predators. Even though their colours can be very vibrant, these caterpillars are rarely noticed by people because they spend most of their time on the undersides of low hanging leaves. Most species aren't very painful if touched, but the numerous spines offer an effective deterrent against many predators.

ABOVE
Spiny Oak Slug *Euclea delphinii*

OVERLEAF
Stinging Rose Slug *Parasa indetermina*

50 // BUGS IN CLOSE-UP

ABOVE
Smaller Parasa *Parasa chloris*

OPPOSITE TOP
Purple-crested Slug *Adoneta spinuloides*

OPPOSITE BOTTOM
Crowned Slug *Isa textula*

OVERLEAF
Slug caterpillar Limacodidae

MOTHS AND BUTTERFLIES // 51

52 // BUGS IN CLOSE-UP

MOTHS AND BUTTERFLIES // 53

54 // BUGS IN CLOSE-UP

MOTHS AND BUTTERFLIES // 55

OPPOSITE TOP
Monkey Slug *Phobetron pithecium*

OPPOSITE BOTTOM
Skiff Slug *Prolimacodes badia*

ABOVE
Saddleback moth *Acharia stimulea*

ATALA BUTTERFLY

These small beauties were once thought to be extinct in the United States, but they are making a comeback now that their host plant has become popular in landscaping. Atala caterpillars feed in large groups throughout the larval stage and even pupate in close proximity to one another. Freshly emerged butterflies are the easiest to photograph because their wings are not yet ready for flight. The wings are also in pristine condition, something not frequently found in older individuals.

PAGES 56–59
Atala Butterfly *Eumaeus atala*

DRAGONFLIES
DAMSELFLIES

AND

DRAGONFLIES AND DAMSELFLIES comprise the order Odonata. These aerial predators are easily identified by their large eyes and long, veined wings. Adults chase and capture prey in mid-air. They will eat just about any insect they can catch, including many which are considered by humans to be pests, such as mosquitoes. Their aquatic larvae are also predatory, snatching up small fish and other tiny aquatic organisms. As adults, dragonflies and damselflies are often found near the aquatic habitats where they lay their eggs, although some species travel far from water.

Dragonflies can usually be distinguished from damselflies by size alone. Not only are most dragonflies longer, but their bodies are much thicker. Some damselfly species can be very large, but they all share a very slender frame. While dragonflies are very strong and agile, damselflies tend to be slower and more dainty. Dragonflies and damselflies are also easy to distinguish by their head-shape: dragonflies have round faces, while damselflies have wide heads with bulging eyes.

Photographing some species of dragonflies and damselflies can be challenging. Certain groups of dragonflies almost constantly cruise up and down rivers or along the shores of lakes, making them nearly impossible to photograph. Others spend a lot of time on a perch, scanning their surroundings for prey, giving a photographer a better opportunity. Staking out popular perches and waiting for a dragonfly to land or slowly approaching a perched dragonfly are the most effective ways to get close views. Because damselflies spend a lot of time perched near the banks of lakes and streams, and tend to be even less wary than dragonflies, they are easier to photograph.

PREVIOUS PAGES
Halloween Pennant *Celithemis eponina*

Butterflies get credit for being the prettiest insects, perhaps the only pretty insect, but some dragonflies have surprisingly beautiful wings. The lovely colours combined with intricate venation patterns create fascinating wings.

OPPOSITE
Common Green Darner *Anax junius*

This is one of the most widespread and abundant species of dragonfly. They are also among the largest dragonflies in the world.

PAGE 64
Damselfly *Zygoptera*

When viewing images of animals we are often drawn to the eyes. Occasionally, focusing on other features can result in a more appealing image, but most of the time an insect's eyes should be visible in the photo. A damselfly's large, bulging eyes are a big part of why macro photographers are drawn to these photogenic creatures.

PAGE 65
Spreadwing damselfly *Lestidae*

While at rest, most damselflies keep their wings folded. However, the aptly named spreadwings keep their wings open while perched.

DRAGONFLIES AND DAMSELFLIES // 65

ABOVE
Damselfly Zygoptera

Damselflies have pseudopupils, dark spots that move around the insect's eye and make it appear as if the insect is following the observer with its eyes. In photographs, the pseudopupils usually give the impression that the damselfly is staring right at the camera.

OPPOSITE
Ornate Pennant Celithemis ornata

Insects are not known for their personalities, but this dragonfly appears to be smiling. It's unlikely that this dragonfly is actually in a cheerful mood, but it highlights the ability of macro photographs to reveal the expressiveness of insect faces.

OVERLEAF
Little Blue Dragonlet
Erythrodiplax minuscula

The blue male and orange female chose to rest on the same perch, providing a perfect example of the sexual dimorphism exhibited by this species.

ABOVE
Rambur's Forktail *Ischnura ramburii*

Damselflies are a colourful bunch. Orange, blue, purple, yellow, and just about every other colour are common among these slender beauties. Even a single species can exhibit different colours. Rambur's Forktail males are green, females are blue, and juveniles can be bright orange like the individual pictured here.

OPPOSITE
Dragonfly *Epiprocta*

From a head-on perspective, a dragonfly's mandibles are hidden, but the strong jaws are visible in this view of a dragonfly's slightly agape mouth. The mouth can open much wider than pictured here, allowing them to capture and quickly consume their prey.

PAGE 72 TOP
Great Blue Skimmer *Libellula vibrans*

Images like this with the entire insect in focus are usually not possible without a technique called focus stacking. The process involves taking multiple images at different points of focus, and then combining them using special software. The in-focus sections of each image are taken and merged together to create a photo with a much greater depth of field, far greater than can be achieved in a single image.

PAGE 72 BOTTOM
Royal River Cruiser *Macromia taeniolata*

Dragonflies have some of the largest eyes in the insect world. These multifaceted orbs cover most of the dragonfly's head and allow it to see in almost all directions at the same time, making it incredibly skilled at capturing prey and avoiding predators.

DRAGONFLIES AND DAMSELFLIES // 71

72 // BUGS IN CLOSE-UP

DAMSELFLY PORTRAITS

These colourful faces represent just a small sample of the variation among damselflies. Damselflies are the perfect subjects for vertical portraits. Macro photographers too often stick with horizontal shots, when some species are much more suited for a vertical orientation.

ABOVE LEFT
Rambur's Forktail *Ischnura ramburii*

ABOVE RIGHT
Florida Bluet *Enallagma pollutum*

PAGES 74–75
Citrine Forktail *Ischnura hastata*

74 // BUGS IN CLOSE-UP

BEES AND WASPS

BEES AND WASPS are members of the order Hymenoptera, which also includes another group of stinging insects, ants. Though these insects are notorious for their painful stings, most people don't realize that many wasps, and even some bees, are incapable of stinging. The stinger is actually a modified ovipositor, the structure used by females for laying eggs. Therefore, of the stinging bees and wasps, only the females have functional stingers. Stings normally result when people unwittingly disturb or get too close to the nests of social bees and wasps.

Honeybees and bumblebees may be the most well-known groups of bees, but these colony builders make up only a small percentage of the bee species in the world. In fact, most species are solitary and do not build large hives. Almost all bees are nectar feeders and play an essential role in pollination, making them some of the most important insects to humans and the environment. Bees are generally not aggressive and stings normally occur only when they are defending a hive or if a person accidently presses against a bee.

Like the social bees, social wasps, such as paper wasps, hornets, and yellow jackets, are the most recognizable. These wasps often construct nests on or near man-made structures, making them a common sight. Close proximity to people also leads to painful stings when people unknowingly disturb the wasps' nest. While wasps will use their stinger in defence, they also use it to paralyse prey which they then feed to their offspring. Many species use their stingers to lay eggs directly inside the bodies of living hosts. Most of these wasps are unable to sting in defence and are therefore harmless to humans, but they do play a very important role in controlling the populations of other insects, some of which are considered by humans to be pests.

Bees and wasps are some of the most difficult insects to photograph. During the day they are constantly on the move and even while feeding they rarely sit perfectly still. With a lot of patience it may be possible to capture a few great images during an afternoon photography session, but a better strategy by far is to look for bees and wasps in the early morning when colder temperatures keep them calm and sedated.

PREVIOUS PAGES
Chalcidid wasp *Conura amoena*

Wasps come in many different styles, and this chalcidid wasp is one of the more sporty models. Though they may look fierce, these wasps are completely harmless to people. Unlike their stinging cousins, chalcidid wasps are parasitic and use their stingers to plant eggs in host species rather than delivering a painful dose of venom. Many parasitic wasps are beneficial to humans because they help control populations of pest insects.

RIGHT
Chalcidid wasp *Brachymeria* sp.

In the middle of the day these small, highly active wasps can be very difficult to photograph. This individual was photographed on a cool December morning while it was in a relatively sedated state.

80 // BUGS IN CLOSE-UP

OPPOSITE TOP
Leaf-cutting bee *Megachile* sp.

Insects are usually much easier to photograph in the early morning because the cooler temperatures keep them calm. If it's cool enough, flying insects, such as this leaf-cutting bee, may be unable to fly. Forced to stand its ground, this bee tried to look as threatening as possible.

OPPOSITE BOTTOM
Long-horned bee *Melissodes* sp.

Despite the common perception that bees are social insects living in large colonies, most bee species are solitary. Many solitary bees, such as this long-horned bee, can be found clinging to plant stems during the night and early morning as they sleep. They don't use their legs, but rather grip a perch with their mandibles to remain in place as they sleep.

ABOVE
Cuckoo wasp *Chrysis angolensis*

These wasps lay their eggs in the nests of other wasps or bees. When the larvae hatch, they proceed to eat the host species' eggs and any food provided by the parents. They lack the ability to sting, but if captured by a predator, or a curious photographer, they tuck in their legs and roll into a ball.

OVERLEAF
Cuckoo bee *Triepeolus* sp.

Cuckoo bees get their name from birds by the same name that also practice the behaviour of parasitizing the nests of other species. With bees and wasps, the practice is much more widespread than in birds, with many different species engaging in this behaviour.

BEES AND WASPS // 85

OPPOSITE
Long-horned bee *Melissodes* sp.

Most of the time, a bee's tongue is either tucked away in its protective sheath or buried in a flower, but bees have long tongues for lapping up nectar. Here, a long-horned bee's tongue is seen just before sliding inside a flower.

ABOVE
Orchid bee *Euglossa dilemma*

Despite being called 'orchid bees,' these vibrant insects don't actually feed from orchids, which do not produce nectar. Rather the males scrape scent from orchids and press it into the grooves on their modified rear legs. The chemical acts as a cologne to lure in females.

PAGE 86 TOP
Square-headed wasp *Ectemnius* sp.

Many wasps and bees look alike when viewed from a distance, and while closely related species can be difficult to distinguish even when viewed up close, a macro lens provides a unique glimpse at the massive amount of diversity among these insects. Square-headed wasps don't look very distinctive from afar, but their faces are unmistakable.

PAGE 86 BOTTOM
Giant ichneumon wasp *Megarhyssa atrata*

Many people are terrified by the sight of these giant wasps because of what appears to be their 10-centimetre stinger, but this insect is harmless to humans. The 'stinger' is the wasp's ovipositor, which the females use to lay eggs in woodboring insects. The extreme size is necessary to reach the larvae, which can burrow deep within wood.

// BUGS IN CLOSE-UP

BEES AND WASPS // 87

PAGE 87
Chalcid wasp Eurytomidae

At less than 3 millimetres in length, this tiny wasp is barely noticeable to the naked eye. While many insects are larger and easier to spot, small hidden gems like this wasp are abundant and the macro photographer should take the time to scan vegetation very closely or risk missing some remarkable insects.

ABOVE
Crown wasp Stephanidae

These wasps are yet another odd-looking group that looks nothing like the typical paper wasp or hornet. The slender bodies, distinctive head, and enlarged back legs make these wasps easy to identify. Like other parasitic wasps, they don't sting. Prior to this photo, this individual was inspecting a dead log on a beach, looking for larvae to parasitize.

OPPOSITE
Potter wasp Zeta argillaceum

Potter (or mason) wasps get their name because many members of this group build their nests out of a mixture of dirt and saliva. These structures can be fairly common on covered walls and overhangs on homes and other buildings. Though these wasps can sting, they are not aggressive like paper wasps and yellow jackets. Taking photos at this magnification requires getting extremely close to the subject, but almost all bees and wasps can be safely approached as long as they are not defending a nest.

FLIES

FLIES belong to the order Diptera, which means 'two wings' in Latin. Unlike other insects, flies only have a single pair of wings. Many types of insects have 'fly' in their common name, and many species of fly mimic other insects like bees and wasps. However, true flies can always be distinguished by their number of wings. Most people are aware of only a few types of flies, such as house, fruit, and horse flies, but there are literally thousands of species in the world. The most familiar flies are the pesky ones that eat our food or our blood, but many flies benefit people by pollinating flowers, eating bothersome insects, or parasitizing pests.

Flies may not seem like very interesting subjects for macro photography, but many of these insects have very colourful and vibrant eyes. Ironically, the flies we despise most, biting horse and deer flies, have some of the most remarkably beautiful eyes of any insect. The best strategy for photographing flies depends on the species. To photograph predatory flies, such as robber flies, or pollinators such as syrphid flies, it is best to wait to approach them until they are feeding because they are less likely to fly away. Other flies, such as soldier flies, tend to be docile and are less likely to fly away even while not feeding, so it is best not to hesitate if a shot presents itself.

PREVIOUS PAGES
Yellow-headed soldier fly *Cyphomyia* sp.

This fly's head is so bright that it seems to be glowing. Many soldier flies have colourful eyes and bodies, but few compare to the striking appearance of the members of this genus.

OPPOSITE
Striped Horse Fly *Tabanus lineola*

Close relatives of the deer fly, horse flies are another nuisance insect that most people would like to see dead. However, like deer flies, their eyes are amazing. Most insects attempt to escape from the macro photographer, but horse flies are one of the few that that come to a person.

PAGE 94
Hanging thief *Diogmites* sp.

Robber flies are aerial predators capable of taking down even large prey like dragonflies. Hanging thieves are unique in that they consume their prey while hanging from perches by their front legs.

PAGE 95 TOP
Syrphid fly *Sphiximorpha willistonii*

The wings, colours, and form of this fly make for a very convincing wasp. Many defenceless insects mimic stinging insects such as bees, wasps, and ants to avoid being eaten by predators.

PAGE 95 BOTTOM
Tachinid fly *Belvosia borealis*

From a distance this fly may look like an average house fly, but *Belvosia* are much larger and have a silver mask with shimmering blue eyes. These flies are parasites of moth and butterfly larvae and pose no threat to humans.

PAGES 96–97
Tachinid fly *Dejeaniops* sp.

Tachinid flies form a large and varied group of insects. These flies are important in the regulation of other insect groups, particularly caterpillars, because tachinid flies are parasitic. The adults feed on nectar and other sources of energy, but they lay their eggs on or inside other insects, especially caterpillars. The larvae develop inside the host and eventually kill it. Some tachinid flies look like regular house flies, but this species is markedly different with numerous spiky hairs, an orange abdomen, and a long proboscis.

94 // BUGS IN CLOSE-UP

FLIES // 95

ABOVE
Stilt-legged fly Micropezidae

These flies have a unique appearance because of their long legs and thin bodies. They support their bodies high on their long legs, giving the appearance that they are on stilts. Many have a habit of waving their front legs around. These flies tend to be less wary than others and often allow photographers to get quite close.

OPPOSITE
Syrphid fly Spilomyia longicornis

These pollinators spend a lot of time feeding in the company of bees and wasps. Not only are their bodies coloured in yellow and black like the stinging species they mimic, but even their eyes show the same warning coloration.

PAGE 100
Deer fly Chrysops sp.

For those who enjoy the outdoors, deer flies probably rank high on the list of most-hated insects. It's not uncommon for multiple flies to swarm a person in search of their next blood meal. For this reason, most people are too busy swatting these flies to take a close look at them. Despite their pest status, these insects have some of the most beautiful eyes in the animal kingdom.

PAGE 101
Syrphid fly Eristalinus aeneus

These flies also go by the name 'hoverflies' because they are frequently seen hovering in one place. They are nectar feeders and while many have colourful eyes, few compare to the red spotted pattern found on the eyes of this species.

FLIES // 101

102 // BUGS IN CLOSE-UP

FLIES // 103

PREVIOUS PAGES
Soldier fly *Raphiocera* sp.

For most flies, their most interesting feature is the eyes, but this species of soldier fly has beautiful colours over its entire body. The eyes have bands of stunning colours, but the green-and-turquoise body really makes this fly stand out.

ABOVE
Stalk-eyed fly *Richardia* sp.

The insect looks a creature from science fiction, but these bizarre flies exist in nature. This stalk-eye feature is not unique to a single species or a single family, but has evolved in several different families. While there is a family composed entirely of stalk-eyed flies, this species is a type of fruit fly.

OPPOSITE TOP LEFT
Robber fly *Holcocephala* sp.

This robber fly from the western Andes is one of many undescribed insects inhabiting the tropics.

OPPOSITE TOP RIGHT
Thick-headed fly *Physocephala* sp.

Like butterflies, many flies have a proboscis for feeding from flowers. On these strange flies, the proboscis is a rigid needle, which the flies keep pointed in the air when they're not feeding.

OPPOSITE BOTTOM
Syrphid fly *Ornidia obesa*

For a fly that frequently breeds on rotting animals and in latrines, this species is remarkably beautiful. Many flies serve a very important function in breaking down organic waste and recycling nutrients.

BEETLES

'BEETLE' is the common name for insects in the order Coleoptera. Many species are easily recognized by their tough exoskeleton. Even their forewings, called elytra, form part of this protective shell. Beetles have more species than any other order of insect and they inhabit almost any environment, including aquatic ecosystems. The feeding habits of beetle species run the gamut from pollen to other insects.

Although they can fly, beetles tend to spend much less time in the air, making them easier to photograph, than some of the more energetic fliers like bees and wasps. Most beetles are also less skittish and will allow a photographer to approach without attempting to flee. Because beetles are frequently attracted to lights and many species are difficult to find during the day, looking near bright lights at night is the best way to find a large number of species.

PREVIOUS PAGES
Broad-nosed weevil Entiminae

With their tough exoskeleton, and no obvious sign of wings, beetles don't look like they're even capable of flight. Unlike the many insects whose wings are always exposed, beetles keep their flying wings safely tucked under their protective forewings when not in flight. When beetles take flight, the forewings lift and the flying wings unfurl.

OPPOSITE
Large-horned bruchid Megacerus sp.

Bright lights are usually a good place to find beetles, including many that are rarely seen during the day. This small beetle was collected at a light during the night and then photographed the next morning when it was released.

PAGE 110
Neptune Beetle Dynastes neptunus

These aptly named rhinoceros beetles can reach tremendous size. This individual was nearly 15 centimetres in length. They are also incredibly strong, and males use their horns to battle each other to win over females.

PAGE 111
Giant Stag Beetle Lucanus elaphus

They may not reach the gigantic sizes of their tropical relatives, but the Giant Stag Beetle is among the largest beetles in the USA. The body of the male, and their mandibles in particular, are much larger than in the female. Despite their appearance, these beetles are quite docile and only use their jaws when fighting with other males.

PAGES 112–113
Long-nosed weevil Ludovix fasciatus

A long snout is characteristic of weevils, but in most species it isn't nearly as long as the body. With this species, not only is the snout unusually long, but the legs and antennae are also exaggerated relative to the body, giving this species a unique appearance among the weevils. In addition to its strange appearance, this species exhibits the odd behaviour of swimming, which is a rare trait in weevils.

112 // BUGS IN CLOSE-UP

BEETLES // 113

OPPOSITE
Festive Tiger Beetle *Cicindela scutellaris*

Tiger beetles are fast, fierce predators, capable of running at incredible speeds relative to their size. They use their super speeds to run down prey and then tear it apart with their massive jaws. Many, such as the Festive Tiger Beetle, are extremely colourful and considered by many to be the most beautiful beetles in the world.

ABOVE
Glowworm *Phengodes* sp.

It doesn't glow nor does it look like a worm, but this is the form of the adult male glowworm. Their name comes from the larva and female glowworm, which do have those qualities. The males have large, feathery antennae capable of detecting pheromones emitted by the females.

116 // BUGS IN CLOSE-UP

BEETLES // 117

OPPOSITE

Leaf beetle Chalepini

These tiny beetles don't look very interesting from afar, but a close view from above reveals a beautiful intricate pattern that looks more like art than an insect exoskeleton.

ABOVE

Leaf beetle Chrysomelidae

While many of the more commonly encountered beetles come in dull shades of brown and black, some species are surprisingly vibrant and colourful. This impressive species spans all the colours of the rainbow.

OPPOSITE
Locust Borer *Megacyllene robiniae*

Goldenrod flowers are popular among many types of pollinators, including the Locust Borer. Not only do they spend a lot of time feeding in the company of fellow pollinators like bees and wasps, but the black and yellow markings also mimic their appearance. A defenceless beetle is easy prey, but many predators avoid insects they think might deliver a painful sting.

ABOVE
Acorn weevil *Curculio* sp.

They may not have flashy colours, but these tiny weevils are some of the cutest insects you can find. The long slender snouts on this species are used to drill into acorns, where females deposit their eggs.

OVERLEAF
Straight-snouted weevil
Estenorhinus sp.

These insects are members of a family of weevils commonly referred to as the primitive weevils. Primitive weevils often have flattened, elongated bodies and straight snouts unlike the curved snouts typical of most other weevils. This odd species also has what appears to be a set of large mandibles at the tip of its snout.

TORTOISE BEETLES

Tortoise beetles get their name from the hard round shell protecting their bodies. Their protective shield extends well over the sides of the beetles to cover their legs, head and antennae. If a predator attacks the beetle, the tortoise will tuck all its appendages under the shell and press its body against a leaf, effectively sealing the body.

PAGES 122–130
Tortoise beetles Cassidini

BEETLES // 123

124 // BUGS IN CLOSE-UP

BEETLES // 125

BEETLES // 127

128 // BUGS IN CLOSE-UP

BEETLES // 129

GRASSHOPPERS, KATYDIDS AND CRICKETS

GRASSHOPPERS, KATYDIDS, AND CRICKETS are members of the order Orthoptera. These insects are common in backyards and easy to identify thanks to their long, powerful back legs which are used for jumping. Most species can also fly, although in some species wings have evolved to serve other purposes such as camouflage. In other cases the wings have been lost altogether. With the exception of certain predatory katydids, most of these insects are herbivores, with some being serious pests in agriculture. Grasshoppers are most familiar to humans because they are diurnal, while most katydids and crickets are nocturnal.

Even though many species can fly, grasshoppers, crickets, and katydids are relatively easy to photograph. Most grasshoppers just stick to jumping, and even when they do fly, they rarely go far. They may jump away the first several times a photographer tries to approach, but with time they usually become less wary. Katydids' camouflage can make them hard to find during the day, but many species are attracted to lights at night. The same defensive behaviour that makes them difficult to spot – remaining perfectly still – also makes them easy to photograph.

PREVIOUS PAGES
Grasshopper Rhytidochrotinae

Most grasshoppers try to be inconspicuous and come in shades of green and brown. Then there are ones like this bright red grasshopper which are almost impossible to miss. Most likely this species is toxic; otherwise it would be quickly eaten by predators.

OPPOSITE
Monkey grasshopper Eumastacidae

Grasshoppers can be excellent subjects for insect portraits. Their elongated faces combined with cross-eyed pseudopupils create a somewhat comical appearance.

PAGE 134
Conehead katydid Copiphora sp.

Though it may look like this katydid is wearing a birthday hat, the crown is actually a part of the animal. This insect belongs to a group called conehead katydids. This individual was lying flat against a leaf trying to blend in, but became curious and peeked over the edge.

PAGE 135 TOP
Katydid Encentra sp.

Some katydids are armoured in rows of spines to deter predators, but for many the primary method of defence is camouflage. The mottled greens and browns on this individual help to disguise it as a pile of debris or a clump of moss. Occasionally, multiple individuals will pile together to form an even less recognizable clump.

PAGE 135 BOTTOM
Katydid Dysonini

As masters of disguise, katydids will mimic different elements of their environment. This individual from mountain forests in Colombia disappears when it sits motionless over a patch of lichen. Searches for these cryptic species are best conducted at night when the subjects are moving about and feeding.

PAGES 136–137
Katydid Typophyllum sp.

Katydids usually have very long antennae, often several times the length of their bodies. Katydids, being nocturnal, have much longer antennae than grasshoppers, which are diurnal, because katydids rely on their long antennae to explore their immediate surroundings in order to navigate and detect possible predators.

134 // BUGS IN CLOSE-UP

GRASSHOPPERS, KATYDIDS AND CRICKETS // 135

ABOVE
Katydid *Typophyllum* sp.

Some katydids are extremely effective at mimicking leaves. The wings of this species are a perfect replica of a dead leaf, right down to the leaf veins, gnarled margins, and specks of debris.

OPPOSITE
Cricket Gryllidae

Unlike many other insects, katydids and grasshoppers hatch as nymphs instead of larvae. The nymphs go through a series of moults before becoming adults. Immediately following each moult, the exoskeleton is very soft and light in colour. This cricket is pure white after having just moulted.

GRASSHOPPERS, KATYDIDS AND CRICKETS // 139

ABOVE
Grasshopper *Aphanolampis* sp.

Most grasshoppers have short, straight, and unremarkable antennae. This species is unique in that its antennae are longer than its body and curve outward at the ends.

OPPOSITE
Stick grasshopper
Pseudoproscopia sp.

Not surprisingly, these grasshoppers are often confused with stick insects. Even their heads are extremely elongated, which completes the stick motif. Despite their spindly appearance, they have strong rear legs and can jump just like other grasshoppers.

GRASSHOPPERS, KATYDIDS AND CRICKETS // 141

GRASSHOPPERS, KATYDIDS AND CRICKETS // 143

OPPOSITE
Predatory katydid Tettigoniidae

Not all katydids are harmless herbivores. Many species, like this one, are predatory and use powerful jaws to tear apart their prey.

ABOVE
Ant-mimic katydid Tettigoniidae

While many katydids have a nocturnal lifestyle and are camouflaged as leaves, moss, or lichen during the day, other species evolved to mimic stinging insects. Ant-mimics such as this species are active during day and look and act just like ants. Although harmless, these katydids are avoided by predators that don't wish to get stung by ants.

LEAF MIMIC

Some species of katydid come in a variety of colours. This leaf mimic has colour forms for multiple types of leaves, from healthy green to dead brown. During the day, each individual hides among leaves of similar colour to its body.

ABOVE AND OPPOSITE
Phaneropterine katydid *Orophus* sp.

GRASSHOPPERS, KATYDIDS AND CRICKETS // 145

LICHEN MIMIC

During the day, this katydid flattens itself against a lichen-covered branch to avoid being seen by predators. The face is beautifully coloured but not visible when the katydid is at rest. A hike through the rainforest by day is unlikely to reveal many katydids, but exploring the same area at night will yield numerous species.

OPPOSITE AND ABOVE
Lichen katydid *Acanthodis* sp.

PEACOCK KATYDID

Many leaf-mimic katydids become a meal if a predator figures out their disguise. The peacock katydid has another trick up its sleeve for those clever predators. When threatened, they fling their wings into the air to reveal the brilliant red undersides and eyespots. The display startles the predator, giving the katydid time to fly away.

ABOVE AND OPPOSITE
Peacock katydid *Pterochroza* sp.

GRASSHOPPERS, KATYDIDS AND CRICKETS // 149

MANTISES AND PHASMIDS

MANTISES AND PHASMIDS, although very similar in appearance, are in different scientific orders. In fact, phasmids are more closely related to grasshoppers and other orthopternas than mantises. Like most orthopterans, phasmids are herbivores, while mantises are carnivores. A key distinguishing characteristic of mantises is the modified front legs, which they use to grasp prey. The arrangement of their folded legs bears a resemblance to human hands folded in prayer, giving them the common name of praying mantis. Despite having different diets, many mantises and most phasmids are similarly long, slender, and stick-like, which is why phasmids go by the common name of stick insects.

Because both mantises and phasmids are well camouflaged and many species are nocturnal, the hardest part of photographing them is finding them in the first place. The best way to find these insects is to hunt for them at night using a headlamp. Once located, mantises and phasmids are fairly easy to photograph because they tend to be slow moving and calm. Many phasmids don't even have functional wings, making it impossible for them to escape a photo shoot.

PREVIOUS PAGES
Praying mantis Acontista sp.

Mantis nymphs lack the wings and size of adults, making them more vulnerable to predation. For this species, the small size has given the nymphs an advantage by allowing them to mimic ants. At this magnification it is clearly a mantis, but from just a couple feet away, this tiny insect looks and moves exactly like an ant.

OPPOSITE
Mantis Macromantis sp.

When threatened, this mantis raises its body and lifts and spreads its arms to reveal the sharply-toothed edges. The overall effect is to make the mantis appear larger and more menacing. If threats fail, they are also capable of delivering a painful bite.

PAGE 154
Stick insect Metriophasma sp.

For many phasmids, the key to surviving the day is to not move. Sitting motionless, these insects can rely on their amazing camouflage to remain invisible to predators. This insect probably won't move at all during the day, waiting for nightfall to forage.

PAGE 155
Stick insect Prisopus sp.

A phasmid's camouflage is usually its first line of defence, but some species have a backup plan if a predator sees past the disguise. This phasmid normally lies flat against a branch, but when a predator gets too close, it raises the rear of its body and flares its wings. The startling display surprises the predator and gives the phasmid a few seconds to fly away.

154 // BUGS IN CLOSE-UP

OPPOSITE
Mantis *Angela* sp.

Although phasmids are the more common stick-like insects, many mantis species also have long stick-like bodies. Here, a slender mantis extends its extremely elongated body over the edge of some vegetation.

ABOVE
Mantis *Vates* sp.

Comb-like antennae are uncommon among mantises, but males in the genus *Vates* possess this interesting characteristic. This type of antennae is most frequently used to detect pheromones of females and most likely it serves such a function for this mantis.

OVERLEAF
Phasmid *Trychopeplus* sp.

This species takes camouflage to the extreme. All parts of the body, limbs, and head are coloured to match moss and covered in bumps and small projections to mimic its texture. Even the green striations in the eyes match the mossy environment of this cryptic creature.

160 // BUGS IN CLOSE-UP

ABOVE
Phasmid *Damasippus* sp.

Most phasmids in the rainforest are nocturnal and rely on camouflage to keep them safe from predators during the day. This brightly coloured species goes against the grain and can be found moving about during the day.

OPPOSITE
Two-striped Walkingstick
Anisomorpha buprestoides

Phasmids exhibit very strong sexual dimorphism, with females being significantly larger than males. Here, the much smaller male mates with a female. Notice the male's rear legs hanging off the female's side as she carries him around.

OVERLEAF
Dead leaf mantis *Metilia* sp.

These mantises spend much of the day hanging upside-down. They dangle limply from a branch, where their coloration and posture make it appear as if they are dead leaves.

MANTISES AND PHASMIDS // 161

162 // BUGS IN CLOSE-UP

MANTISES AND PHASMIDS // 163

ABOVE

Hooded mantis *Choerododis rhombifolia*

Mantises may be top predators among insects, but even large individuals like the hooded mantis make a tasty snack for other animals. During the day, this species keeps its flattened profile pressed against a leaf. The hood helps the mantis blend in with the leaf.

OPPOSITE

Stick insect *Phanocles sp.*

This gangly creature is perfectly camouflaged to blend in with the mossy twigs of high elevation tropical forests. The curved body and appendages and mottled colours enhance the illusion and make it very difficult to identify this creature as an insect.

OVERLEAF

Grizzled Mantis *Gonatista grisea*

These mantises are masters of camouflage. The flightless nymphs are especially cryptic and almost disappear when standing over a piece of lichen like the individual pictured here. Adults of the species have slightly different coloration and patterning that resembles tree bark rather than lichen.

PAGE 168

Stick insect *Lamponius guerini*

The parts of the insect in this photo can be difficult to identify, but that's part of the disguise. This phasmid has positioned all its appendages parallel with its body to look like one long stick. With the legs and antennae no longer distinguishable, predators have a very hard time finding the phasmid.

HATCHING

Praying mantises lay their eggs in a hard case that protects them from the elements and predators. When the mantises hatch, they wriggle their way out of the case and emerge in a large mass. At first they resemble a small grub, but eventually the body unfolds into a tiny mantis.

ABOVE AND OVERLEAF
Chinese Mantis
Tenodera aridifolia sinensis

TRUE BUGS

TRUE BUGS are a diverse group of insects in the order Hemiptera. This order includes leafhoppers, planthoppers, treehoppers, cicadas, stink bugs, assassin bugs, and many more. These groups often look nothing like each other, but the one defining characteristic of this order is the sharp beak used for piercing and sucking. Most true bugs consume liquids from plants, but some species are predatory and spear other insects, injecting them with venom and digestive enzymes. Still other species are parasitic and drink blood from other creatures, sometimes even humans. Care should be taken when working with the predatory bugs because many can use their beaks in defence, and a bite from these insects can be very painful.

Most true bugs are diurnal, although some species are drawn to lights at night. Cicadas, in particular, are much easier to find at lights, because they are frequently high in trees during the day and take flight if approached. To find others, especially the smaller hoppers, one must explore vegetation very closely or risk missing these fascinating insects. Fortunately, while most true bugs can fly, many are reluctant to do so, making them fairly easy to photograph.

PREVIOUS PAGES
Oak Treehopper *Platycotis vittata*

Oak Treehoppers are some of the most beautifully coloured hoppers found in North America. Many have a large horn projecting from the head. As the name suggests, this species feeds on oak trees. Fortunately, they don't cause any significant damage to the trees.

OPPOSITE
Net-winged hopper *Biolleyana* sp.

Most hoppers are compact and their wings fold up against their bodies, much like a beetle. However, the net-winged hoppers have large wings with intricate patterns that remain open. Like most hoppers, they are quite small, so these beautiful creatures are rarely noticed.

PAGE 176
Ambush bug *Phymata americana*

Ambush bugs are tiny predators usually found perched on flowers. Their coloration helps them blend in and remain unseen by the pollinators visiting the flower to feed. When prey arrives, ambush bugs grasp it with their strong front legs and inject a powerful dose of venom through their needle-like proboscis. The potent venom allows these predators to capture prey several times their size.

PAGE 177
Lantern fly *Odontoptera carrenoi*

While most hoppers are quite small, lantern flies are relatively large. This individual is about three centimetres in length and some are even larger. One of the main characteristics of these hoppers is the long, upward-curving nose. This species has a false eye-spot near its rear so that predators are more likely to take a chunk out of the hopper's wings rather than its head.

176 // BUGS IN CLOSE-UP

OPPOSITE TOP
Big-eyed toadbug *Gelastocoris oculatus*

From above, toadbugs look like tiny bits of sand and gravel, which helps them blend in with their riverbank environments. From the front, however, they appear to be aliens. These tiny predators jump on prey and grasp it with their clawed front legs.

OPPOSITE BOTTOM
Thorn treehopper *Umbonia crassicornis*

Thorn treehoppers are particularly fond of acacia trees, which are covered in sharp spines. The treehoppers look almost identical to the spines on the trees, helping them blend in among the thorns. Like the spines on the trees, the hopper thorns are quite sharp and biting down on one poses quite a challenge to potential predators.

ABOVE
Assassin bug *Sinea* sp.

As the name suggests, assassin bugs are deadly predators. They have a sharp, needle-like proboscis which they stab into prey and inject a dose of lethal venom. Left alone, they pose no threat to humans, but if harassed they can give a very painful bite.

OVERLEAF
Oak Treehopper *Platycotis vittata*

Most insects don't invest any effort in caring for their offspring. Treehoppers are some of the few creatures that stick around after laying their eggs and even watch over their offspring during the nymph stage. An adult treehopper can often be seen surrounded by over a hundred tiny nymphs at different stages of growth.

ABOVE
Shield bug Acanthosomatidae

Shield bugs are close relatives of stink bugs and are similar in both appearance and their ability to secrete a foul-smelling chemical when disturbed. The individual pictured here is still a nymph and has not yet developed wings, providing an unobstructed view of the shield covering the insect's body.

OPPOSITE TOP
Boxer sharpshooter *Peltocheirus* sp.

This hopper looks like it's sporting boxing gloves, but those odd legs help the hopper to remain undetected by predators. While at rest, the hopper presses its green body against a leaf and brings its legs against the side of its head. The overall effect is to change the insect's profile to look more like a piece of debris than a meal.

OPPOSITE BOTTOM
Flatid planthopper Flatidae

The flattened bodies of these hoppers allow them to lie smooth against the profile of a branch or tree trunk. Many are also very well camouflaged to further disappear. This species is quite visible on a small brown stem against a green background, but it is almost impossible to see when resting on a patch of lichen.

OPPOSITE
Spittle bug Cercopidae

Froghoppers are best known for their nymph stage, when they are surrounded by a protective spittle-like nest. The adults create this protective home with frothy plant sap and the young stay here until they reach adulthood.

ABOVE
Treehopper *Cyphonia trifida*

A tiny, defenceless hopper is easily gobbled up by hungry predators, but a hopper covered in long, irregular spines can be more challenging to eat. This protective mechanism also makes for some of the strangest looking insects found in the tropics. Most treehoppers are easy to photograph as long as they are approached slowly, and even if they fly away, they rarely go far.

OVERLEAF
Cicada Cicadidae

Despite their large size, cicadas are a rather infrequent sight because they spend most of their time in the forest canopy. Their song, however, is instantly recognized by anyone who lives near these extremely loud insects. Where cicadas are abundant, their song becomes a constant drone, drowning out all other insect sounds in the forest. Cicada larvae live underground, sometimes for many years, before emerging to transform into adults.

186 // BUGS IN CLOSE-UP

TRUE BUGS // 187

188 // BUGS IN CLOSE-UP

ABOVE

Horseshoe treehopper *Cladonota* sp.

With its long, backwards-curving horn, this treehopper doesn't look much like an insect. Even if a predator is able to spot the treehopper, the irregular shape makes it much more difficult to swallow.

OPPOSITE

Leaf-footed bug Coreidae

These insects get their name from their enlarged back legs, which on some species look like parts of leaves. Many are also brown in coloration, which further helps disguise them as dead leaves. The species pictured here is more beautifully coloured and lacks the leaf-like features. All members of this family use their beaks to feed on plants.

LEAFHOPPERS

Despite their beautiful, vibrant colours, leafhoppers are rarely noticed or photographed because they are only a few millimetres in length. However, if one takes the time to closely examine plants near the forest floor, it is often possible to find a variety of these beautiful hoppers in just a few square metres.

PAGES 190–193
Leafhopper Cicadellidae

SPIDERS

SPIDERS are perhaps the most reviled of the arthropods. Part of the fear and hatred is understandable, because a small number of spider species are highly venomous. However, the vast majority of spiders pose no threat to humans and are needlessly squashed by shoes and rolled-up newspapers. Even the deadly species have no desire to harm humans and would much rather be left alone.

Spiders are predators and have a variety of methods for capturing their prey. The most well-known is the web that many spiders build to ensnare flying insects. Others ambush prey, run it down, catch it in a silk net, or snatch it from the entrance of hidden tunnels in the ground. Once in the spider's grasp, prey is pierced with sharp fangs and injected with venom and digestive enzymes that turn the insect's insides into a liquid that the spider can easily consume. Many people assume that only the deadly species are venomous, but most spiders inject venom, with varying degrees of potency.

Since they can't fly, spiders are relatively easy to photograph. Some faster-moving species like jumping spiders can pose more of a challenge, but most spiders will eventually calm down and sit still for photographs. Despite their reputation, the vast majority of spiders are not aggressive and can be safely handled. They may seem scary from a distance, but high magnification portraits often reveal interesting, even charming, faces. This is especially true with the jumping spider, perhaps the most photogenic of all the arthropods.

PREVIOUS PAGES
Moustached Jumping Spider
Phidippus mystaceus

Few people would describe spiders as cute, but this moustached jumping spider looks more like a furry Muppet than a terrifying monster. Many spiders, and especially the fuzzy members of the *Phidippus* genus, are surprisingly adorable, and a bit goofy, when viewed up close. The key is to photograph them head-on. Photos at eye level, or even a bit below eye level, provide a much more interesting perspective on most bugs.

OPPOSITE
Cardinal Jumping Spider
Phidippus cardinalis

This individual has not quite reached maturity yet. Unlike insects, which begin life as larvae, spiders start as miniature versions of adults. As they grow, they go through a series of moults, each time shedding their skin. When this spider hatched from its egg, it was less than one millimetre in length, but already it is over one centimetre long.

PAGE 198
Nursery web spider Pisauridae

Although it looks neon green in the photo, this spider blends in very well with the leaves that it hides under during the day. At night, the spider emerges to hunt under the cover of darkness when its bright colours won't be seen.

PAGE 199
Wandering spider Ctenidae

Many spider families can be distinguished based solely on their eye arrangements. In nature, the eye arrangements can be difficult to make out due to the small size of most spider faces, but examining high magnification portraits is a great way to see them up close. Wandering spiders are large, nocturnal hunters that actively hunt instead of building webs.

SPIDERS // 199

ABOVE
Apache Jumping Spider
Phidippus apacheanus

A notable characteristic of *Phiddipus* jumping spiders is their bright, iridescent chelicerae. The chelicerae are the large fleshy part of the fangs. Here a female Apache Jumping Spider displays her beautiful turquoise chelicerae.

OPPOSITE TOP
Jumping spider *Phidippus insignarius*

When it comes to courting a female, few arthropods rival the elaborate displays of male jumping spiders. The females are very selective and won't settle for a male unless he has the right dance moves. In the case of *Phidippus insignarius*, the male raises his body, lifts his front legs in the air, and shuffles from side to side. Occasionally, an unsuccessful male not only fails to win over a mate, but also becomes a meal for the larger female.

OPPOSITE BOTTOM
Jumping spider *Habronattus calcaratus*

Jumping spiders in the genus *Habronattus* have some of the most elaborate courtship displays among spiders. As part of the display, many males use special decorations and colours on their bodies to impress the females. The male *Habronattus calcaratus* is mostly a uniform brown colour, but when performing for a female, he raises his front legs to reveal a shiny green underside.

OVERLEAF
Magnolia Green Jumping Spider
Lyssomanes viridis

Most jumping spiders lay their eggs in a thick silk nest. The eggs are usually not visible, but the Magnolia Green Jumping Spider lays her eggs in a thin bed of silk on the underside of a leaf. This female is standing guard over her clutch of eggs.

SPIDERS // **201**

ABOVE

Magnolia Green Jumping Spider
Lyssomanes viridis

Although this spider appears to have a black eye, the truth is a bit more complex. While jumping spiders have eight eyes, they don't look through all of them at the same time. Instead, the retina moves around inside the head as the spider looks in different directions. In some species, such as the Magnolia Green Jumping Spider, the retina can be seen when the spider is looking through the eye, making the eye appear black. In this case the spider is looking directly at the camera through its right eye (or the one on the left as we look at it).

OPPOSITE

Dimorphic Jumping Spider
Maevia inclemens

Unlike many spiders which build webs or ambush prey, jumping spiders actively pursue their prey and pounce on it. Jumping spiders have excellent eyesight, which allows them to follow their prey and execute perfectly-timed jumps. A distinguishing feature of jumping spiders is their two large front eyes that act as binoculars, allowing them to see prey from a distance. The Dimorphic Jumping Spider gets its name from the fact that males come in two completely different forms, one with white legs, a black body, and three tufts of hair on the head, while the other has zebra-striped legs, a greyish body, no tufts, and yellow palps.

206 // BUGS IN CLOSE-UP

OPPOSITE
Northern Crab Spider
Mecaphesa asperata

Unlike most insects, spiders protect their eggs. Some carry their egg case with them, while others, such as crab spiders, conceal their egg case and guard it until the young hatch.

ABOVE
Jumping spider *Phidippus putnami*

Jumping spiders are bold predators, often attacking prey over twice their own size. This *Phidippus putnami* has taken a cricket about the same size as itself. Some of the larger *Phidippus* species can even capture lizards and frogs.

OVERLEAF
Jumping spider *Tutelina elegans*

Male jumping spiders can become quite aggressive towards each other when competing for a female. The fights usually begin with threatening displays that allow the spiders to size each other up. Physical violence is usually avoided because the smaller male usually leaves before the contest gets physical. However, if the males are evenly matched, the fights can become more severe.

208 // BUGS IN CLOSE-UP

SPIDERS // 209

210 // BUGS IN CLOSE-UP

OPPOSITE TOP
Ant-mimic spider Corinnidae

Even though they are themselves predators, small spiders can quickly become a meal for many animals. Some species mimic less appetizing creatures such as ants. This individual's body is modified to look like the segmented body of an ant, and it uses its front set of legs like antennae, waving them about rather than using them for walking.

OPPOSITE BOTTOM
Ground crab spider Xysticus sp.

Many crab spiders are ambush predators that stake out flowers and wait for pollinators to visit. Members of Xysticus, on the other hand, hunt for prey on the forest floor. Their cryptic coloration makes them nearly invisible to passing prey. They use their long sets of front legs to grasp prey and then inject it with venom.

ABOVE
Rabid Wolf Spider Rabidosa rabida

Bugs are often thought to be dirty creatures, but many species like to keep themselves clean. This wolf spider may look as if it is about to chew on its own leg, but it is actually in the process of grooming.

OVERLEAF
Tarantula Theraphosidae

Tarantulas are very large and hairy spiders. At 8 centimetres in length this is a relatively small individual, but some tarantulas are large enough to kill large prey such as rodents and birds.

MORE AMAZING BUGS

216 // BUGS IN CLOSE-UP

Thus far, only members from about a quarter of the insect and arachnid orders have been covered. These orders contain the majority of the insects commonly encountered, yet there are many others that contain fewer, less common, very small, or difficult to find species. This chapter covers a small sample of these other creatures. Though less frequently encountered, these diverse groups contain some amazing species and tracking them down is well worth the effort.

PREVIOUS PAGES
Owlfly Ascalaphidae

The adult owlfly is a rather attractive creature that strongly resembles a dragonfly. Like dragonflies they are aerial predators, but their long club-tipped antennae are a distinctive feature of owlflies.

OPPOSITE
Owlfly larvae Ascalaphidae

Owlfly larvae are very strange beasts. The large gaping jaws, groupings of six eyes on either side of the head, and protuberances surrounding the body create a truly alien creature. The larvae are well camouflaged and wait for unsuspecting prey to wander close enough to be snatched up by the powerful jaws.

OVERLEAF
Sawfly larvae Symphyta

Sawfly larvae may look like caterpillars, but adult sawflies are an entirely different creature and look nothing like butterflies. Sawfly larvae have some subtle differences from butterfly larvae, including a lack of prolegs. Instead, they only have three pairs of true legs near the head. They feed in large groups and when they feel threatened they lift their rears and form an 'S' shape.

PAGE 220
Dacetine ant *Daceton armigerum*

The jaws of these ants lock open and are triggered by tiny hairs between the mandibles. When prey triggers the hairs, the powerful jaws clamp shut. The ants can also sting their prey to further subdue it. For large prey, several ants will work together to pull the victim's legs apart to prevent it from putting up a fight as they carry it back to the nest.

PAGE 221
Antlion Myrmeleontidae

These insects get their name from their larvae, which construct conic depressions in sandy soil where they trap and devour ants. Adults are less often seen, because they are short-lived and mostly fly at night. They look similar to damselflies, but their large curved antennae are unique to these insects.

PAGES 222–223
Cockroach Blattodea

Cockroaches have a bad reputation for being pests that invade homes and ruin food. While this is true for a small number of species, most roaches have no interest in sharing a home with humans. This beautiful species inhabits tropical lowland forests.

PAGES 224–225
Scorpionfly *Panorpa* sp.

Although 'fly' is in the name, these strange insects are in their own order. They get their name from the male genitalia that bear a striking resemblance to a scorpion's tail. Unlike a scorpion, however, scorpionflies are harmless. Perhaps the most distinguishing characteristic is the long snout. These insects are often found in wet forested areas where they eat dead and dying insects.

222 // BUGS IN CLOSE-UP

MORE AMAZING BUGS // **223**

226 // BUGS IN CLOSE-UP

OPPOSITE TOP
Tailless whip scorpion *Amblypygi*

Most bugs tend to look less terrifying when viewed up close, but tailless whip scorpions still resemble nightmarish creatures. However, their startling appearance belies their harmlessness. These predators only pose a threat to small arthropods and can only give a human a small pinch if they are handled roughly. They hunt at night, generally in dark environments such as caves, using their long, modified front legs as feelers to locate prey.

OPPOSITE BOTTOM
Sun spider *Soifugae*

Sun spiders are arachnids and look similar to spiders and scorpions but have several key differences, most notably the pair of powerful pincers which they use to tear apart their prey. They don't inject venom and are relatively harmless to humans.

ABOVE
Harvestman *Protimesius* sp.

Also known as 'daddy longlegs' in the USA, these arachnids are easily distinguished by their long spindly legs and tiny red bodies. The tropical species pictured here is similar in appearance to a temperate harvestman with the exception of the bizarre grasping claws, which are an uncommon feature for members of this family.

OVERLEAF
Flat-headed mayfly *Stenacron* sp.

Mayflies are some of the shortest-lived insects in the world, with some species surviving for less than a day. Given their short lifecycle, they have no need to feed. Their only goal is to mate during their brief window of adult life.

228 // BUGS IN CLOSE-UP

MORE AMAZING BUGS // 229

MORE AMAZING BUGS // 231

MANTISFLY

Most people are aware of the praying mantis and some know of lacewings, but the bizarre creature that resembles a cross between the two is less familiar. From a distance, they are easily confused with lacewings, and even up close they have many of the same characteristics, with the exception of their grasping front legs which look just like those of a praying mantis.

OPPOSITE AND ABOVE
Green Mantisfly *Zeugomantispa minuta*

DOBSONFLY

From the head down, male and female dobsonflies look almost identical. The bodies of the males are somewhat larger, but that's nothing compared to the extreme difference in the size of the jaws. Males have gigantic, fearsome-looking pincers. Though they look menacing, the jaws are weak and only used to impress females.

ABOVE AND OPPOSITE
Dobsonfly Corydalinae

MACRO

For those interested in macro photography, the most pressing question always seems to be what type of camera and lens are best. Almost any DSLR or other interchangeable lens camera can produce great macro images. For those interested in taking high magnification images, Canon brand may be best because they offer a specialty macro lens designed solely for this purpose. Taking macro images doesn't actually require a dedicated macro lens. Other equipment including extension tubes, diopters, reversing rings, and teleconverters are cheap ways of allowing other lenses to achieve macro magnifications, often with excellent image quality. However, those who plan on shooting a lot of macro may wish to invest in a dedicated macro lens. Most macro lenses are very sharp and produce beautiful images, so picking the right brand isn't much of an issue. The focal length is generally a more important issue when deciding on a lens. Many photographers find that something in the 100 to 150 millimetre range provides a good balance between weight, price, focusing distance, and bokeh.

When beginning a foray into macro photography, the learning curve can be steep as one attempts to overcome the challenges that come along with this specialization. The first struggle is getting proper focus. People often think that today's advanced autofocus has eliminated the need for manual focus, but that is not the case with macro photography. Even the best macro lenses are very slow to focus, and when they finally do, are often inaccurate. The high magnification means that the depth of field is razor thin, especially at higher magnifications. Thus, focusing on the insect is usually not enough because only part of the creature will be in focus. Focus must be targeted at a specific point on the bug, usually the eyes. Focusing on a small target such as insect eyes is much easier and quicker if done manually.

Next, the problem becomes keeping the bug in focus. For larger wildlife, the task is fairly easy, but when the depth of field can be less than a millimeter and the target is a small insect, it becomes very easy to lose track of even slow-moving bugs. Even when the insect is sitting perfectly still, slight movements made by the photographer can put the bug out of focus. With macro photography, the best approach is to focus the lens to the desired magnification and then move the camera forward or backward to achieve focus. Stabilizing the camera is critical for achieving and maintaining focus. A tripod and macro rail provide the best option for stationary bugs, but those shooting handheld can still brace themselves by getting low and using their elbows for support or leaning against a tree. A great technique for lenses with a short working distance is to grip a bug's perch with the thumb and pointer finger and rest the tip of the camera lens on

This image of a small chalcidid wasp sitting on the author's index finger was taken at maximum magnification using a regular macro lens. This gives some perspective on the size of some of the insects illustrated in this book. It also shows that the photographer requires more than just a regular 1:1 magnification macro lens in order to obtain many images such as these.

the wrist of the same hand. This supports the camera and fixes the distance between the bug and the camera lens, making it much easier to focus. Though challenging at first, with practice, this technique becomes much easier.

Obtaining proper focus is important, but by itself not always enough to guarantee sharp images unless the shutter speed is fast enough. The problem with using a fast shutter speed is that this usually requires using a wide aperture, which would make the already thin depth of field that much thinner. In direct sunlight, this is not a problem, but the harsh light creates strong highlights and shadows which usually result in less appealing images. Thus, shooting bugs without the aid of a tripod or external flash is rarely practical unless an extremely shallow depth of field is the desired effect. More often, photographers choose to use a tripod, external flash, or both. Tripods work well, but they require the bugs to sit still, something many bugs don't do when a photographer gets too close. Shooting in the early morning

when cooler temperatures keep bugs sedated is the best strategy for those wishing to use a tripod. Another option is an external flash attached to the camera with a bracket, which provides enough light for a narrow aperture to be used. However, the flash or flashes must be diffused or the light will be just as harsh as direct sunlight.

Another key element of macro photography is learning to work with live insects. Unlike other wildlife, which can be photographed from a distance, bugs usually require one to get very close. The problem is that most bugs can fly and don't like large creatures to get too close. Even those that can't fly can often scurry away into vegetation and disappear long before a photographer can press the shutter. Therefore, the macro photographer must learn how to approach bugs without scaring them away. Moving very slowly and coming at bugs from an angle that doesn't cast a shadow over them is usually the best approach. An understanding of bug behaviour can also help the photographer pick a time to photograph bugs when they are less likely to flee. For example, many bugs are less concerned with nearby humans while they are feeding or mating. The best way for macro photographers to increase their chances of successfully photographing bugs is through trial and error. Different insects have different responses to people and the only way to learn how to approach them is to try over and over again.

Regardless of the challenges, macro photographers have the advantage of an almost unlimited supply of interesting subjects to photograph. A nature photographer could spend the entire day photographing wildlife and only find a few mammal species, but the macro photographer could easily find over 100 species of bugs. Many insects can be found in backyards and small parks, whereas larger animals may require bigger tracts of land. Even though bugs are very diverse, many amazing species exist that are difficult to find and photograph without knowledge of their life histories. Information such as the plants they feed on, their habitat, and period of activity, are important information that macro photographers should invest time in learning if they wish to expand their collection of bug images.

Most of the work involved in creating beautiful images comes before the shutter is triggered, but post processing is an integral part of any field of photography, including macro. Often only minor adjustments are required, but there is one processing technique that can make a huge difference in macro photography. Focus stacking is a method of increasing the depth of field beyond what is capable with a single image. In many situations, the thin depth of field limits the angles one can shoot at without causing most of the subject to be out of focus. Focus stacking combines images shot using the same composition but focused at slightly different depths to create a single image that contains all the in-focus areas. This allows a photographer to shoot from any angle and still get all the desired parts of the subject in focus. The technique requires a lot of practice and patience because the insect must remain almost perfectly still while the series of images are taken or the stacking procedure will not work properly.

Ultimately, taking macro photographs of living insects requires an investment of time and money and a large reservoir of patience, but mother nature has done most of the work for us by offering up an astonishing variety of stunningly lovely, bizarre and colourful bugs to work with. A beautiful image of an exquisite bug is just a camera click away.

ACKNOWLEDGMENTS

Most of all I thank my lovely wife Leah for not only supporting me both emotionally and financially, but for not getting too upset when I occasionally turn the dining room table into a studio or show up at the front door holding a giant spider or venomous snake.

I also want to thank the extremely helpful community of bug experts and enthusiasts on BugGuide and Facebook for helping me to identify many of the organisms I photograph.

Thank you to my friend Natalia Ocampo Peñuela for helping me plan my trip to Colombia and introducing me to all the wonderful people who helped me during my stay. I especially want to thank Gilberto Collazos Bolaños who welcomed me into his home and was a great friend and guide during my time in Alto Anchicaya, Colombia, where I found some of the most amazing creatures I've ever seen in my life.

Thank you to Jeff Pippen and the Duke Forest for issuing me a permit and allowing me to capture many of my images in North Carolina.

FURTHER READING

Bugguide.net is an excellent source of information on bugs in North America. The site has images and information about many species and visitors can upload photos of species that they are unable to identify.

IMAGE DETAILS

Images taken in North Carolina, USA, except for the following:

Alto Anchicaya, Colombia: 27, 52–53, 66, 90–91, 104, 105, 130–131, 142, 144, 145, 154, 155, 156, 157, 158–159, 160, 164, 165, 175, 177, 185, 186–187, 188, 190, 191, 192, 193, 226, 232, 233.

Cali, Colombia: 110, 117.

California, USA: 84, 226.

Colombia: 122, 123, 124, 125, 126, 127, 128–129.

Florida, USA: 35, 56, 57, 58–59, 60–61, 67, 68–69, 70, 72, 73, 76–77, 79, 80, 85, 88, 94, 105, 114, 161, 166–167, 178, 200, 201, 221.

La Mesenia, Colombia: 32–33, 41, 42–43, 44, 65, 96–97, 106–107, 120–121, 133, 135, 136–137, 168, 184, 198.

Leticia, Colombia: 18, 23, 26, 38–39, 64, 71, 98, 102–103, 112–113, 116, 134, 138, 139, 140, 141, 143, 146, 147, 148, 149, 150–151, 153, 162–163, 182, 183, 189, 199, 210, 212–213, 214–215, 217, 220, 222–223, 227.

Puerto Vallarta, Mexico: 87, 89, 109.

INDEX

A

Acanthodis sp. 146, 147
Acanthosomatidae 182
Acharia stimulea 40, 55
Acontista sp. 150–151
Acorn weevil 119
Actias luna 12
Adelpha serpa 27
Adoneta spinuloides 51
Amblypygi 226
Ambush bug 176
Amorpha juglandis 21
Anax junius 63
Angela sp. 156
Anisomorpha buprestoides 161
Ant-mimic katydid 143
Ant-mimic spider 210
Antheraea polyphemus 14, 15
Antlion 221
Apache Jumping Spider 200
Aphanolampis sp. 140
Artace cribraria 30
Ascalaphidae 214–215, 217
Assassin bug 179
Atala Butterfly 56, 57, 58–59

B

Belvosia borealis 95
Big-eyed toadbug 178
Biolleyana sp. 175
Black Swallowtail 16–17, 24
Black-blotched Prominent 46
Blattodea 222–223
Boxer sharpshooter 183
Brachymeria sp. 79
Broad-nosed Weevil 106–107
Brown-shaded Gray Moth 26
Brush-footed Butterfly 27

C

Cardinal Jumping Spider 197
Cassidini 122, 123, 124, 125, 126, 127, 128–129
Celithemis eponina 60–61
Celithemis ornata 67
Ceratomia undulosa 20
Cercopidae 184
Chalcid wasp 87
Chalcidid wasp 76–77, 79
Chalepini 116
Chinese Mantis 169, 170–171
Choerododis rhombifolia 164
Chrysis angolensis 81
Chrysomelidae 117
Chrysops sp. 100
Cicada 186–187
Cicadellidae 190, 191, 192, 193
Cicadidae 186–187
Cicindela scutellaris 114
Citheronia regalis 22
Citrine Forktail 74, 75
Cladonota sp. 188
Cloudless Sulphur 10–11
Cockroach 222–223
Common Green Darner 63
Conehead katydid 134
Conura amoena 76–77
Copiphora sp. 134
Coreidae 189
Corinnidae 210

Corydalinae 232, 233
Cricket 139
Crown wasp 89
Crowned Slug 51
Ctenidae 199
Cuckoo bee 82–83
Cuckoo wasp 81
Curculio sp. 119
Curve-lined Owlet 27
Cyphomyia sp. 90–91
Cyphonia trifida 185

D

Dacetine ant 220
Daceton armigerum 220
Damasippus sp. 160
Damselfly 64, 66
Datana perspicua 19
Dead leaf mantis 162–163
Deer fly 100
Dejeaniops sp. 96–97
Diaethria anna 18
Dimorphic Jumping Spider 205
Diogmites sp. 94
Dobsonfly 232, 233
Dot-lined White 30
Double-toothed Prominent 45
Dragonfly 71
Dynastes neptunus 110
Dysonini 135

E

Eastern Tiger Swallowtail 36
Ectemnius sp. 86
Eighty-eight Butterfly 18

INDEX // 239

Enallagma pollutum 73
Encentra sp. 135
Entiminae 106–107
Epiprocta 71
Eristalinus aeneus 95
Erythrodiplax minuscula 68–69
Estenorhinus sp. 120–121
Euclea delphinii 47
Euglossa dilemma 85
Eumaeus atala 56, 57, 58–59
Eumastacidae 133
Eurytomidae 87

F
Festive Tiger Beetle 114
Flat-headed mayfly 228–229
Flatid planthopper 183
Flatidae 183
Florida Bluet 73

G
Gelastocoris oculatus 178
Geometridae 23
Giant ichneumon wasp 86
Giant Stag Beetle 111
Giant Swallowtail 35
Glowworm 115
Gonatista grisea 166–167
Grasshopper 130–131, 140
Great Blue Skimmer 72
Green Mantisfly 230, 231
Grizzled Mantis 166–167
Ground crab spider 210
Gryllidae 139

H
Habronattus calcaratus 201
Halloween Pennant 60–61
Hanging thief 94
Harris's Three Spot 31
Harrisimemna trisignata 31
Harvestman 227
Hemaris diffinis 31
Hickory Horned Devil 22
Holcocephala sp. 105

Hooded mantis 164
Horseshoe treehopper 188

I
Inch worm 23
Iridopsis defectaria 26
Isa textula 51
Ischnura hastata 74, 75
Ischnura ramburii 70, 73

J
Jumping spider 201, 207, 208–209

K
Katydid 135, 136–137, 138

L
Lamponius guerini 168
Lantern fly 177
Large-horned bruchid 109
Leaf beetle 116, 117
Leaf-cutting bee 80
Leaf-footed bug 189
Leafhopper 190, 191, 192, 193
Lestidae 65
Libellula vibrans 72
Lichen katydid 146, 147
Limacodidae 52–53
Little Blue Dragonlet 68–69
Locust Borer 118
Long-horned bee 80, 84
Long-nosed weevil 112–113
Lucanus elaphus 111
Ludovix fasciatus 112–113
Luna Moth 12
Lyssomanes viridis 202–203, 204

M
Macromantis sp. 153
Macromia taeniolata 72
Maevia Inclemens 205
Magnolia Green Jumping Spider 202–203, 204
Mantis 153, 156, 157
Mecaphesa asperata 206

Megacerus sp. 109
Megachile sp. 80
Megacyllene robiniae 118
Megarhyssa atrata 86
Melissodes sp. 80, 84
Metilia sp. 162–163
Metriophasma sp. 154
Micropezidae 98
Monkey grasshopper 133
Monkey Slug 54
Moustached Jumping Spider 194–195
Myrmecopsis sp. 32–33
Myrmeleontidae 221

N
Nadata gibbosa 25
Neptune Beetle 110
Nerice bidentata 45
Net-winged hopper 175
Northern Crab Spider 206
Nursery Web Spider 198

O
Oak Treehopper 172–173, 180–181
Odontoptera carrenoi 177
Oligocentria lignicolor 45
Orchid bee 85
Ornate Pennant 67
Ornidia obesa 105
Orophus sp. 144, 145
Owlfly 214–215
Owlfly larvae 217

P
Panorpa sp. 224–225
Papilio cresphontes 35
Papilio glaucus 36
Papilio polyxenes 16–17, 24
Papilio troilus 37
Parasa chloris 50
Parasa indetermina 48–49
Peacock katydid 148, 149
Peltocheirus sp. 183
Pennisetia marginata 34
Phaneropterine katydid 144, 145

Phanocles sp. 165
Phasmid 158–159, 160
Phengodes sp. 115
Phidippus apacheanus 200
Phidippus cardinalis 197
Phidippus insignarius 201
Phidippus mystaceus 194–195
Phidippus putnami 207
Phobetron pithecium 54
Phoebis sennae 10–11
Phymata americana 176
Phyprosopus callitrichoides 27
Physocephala sp. 105
Pisauridae 198
Platycotis vittata 172–173, 180–181
Polyphemus Moth 14, 15
Potter wasp 88
Praying mantis 150–151
Predatory katydid 142
Prisopus sp. 155
Prolimacodes badia 54
Protimesius sp. 227
Pseudoproscopia sp. 141
Pterochroza sp. 148, 149
Purple-crested Slug 51

R
Rabid Wolf Spider 211
Rabidosa rabida 211
Rambur's Forktail 70, 73
Raphiocera sp. 102–103
Raspberry Crown Borer 34
Rhytidochrotinae 130–131
Richardia sp. 104
Robber fly 105
Royal River Cruiser 72

S
Saddleback moth 40, 55
Saturniidae 41, 42–43, 44
Sawfly larvae 218–219

Schizura leptinoides 46
Scorpionfly 224–225
Shield bug 182
Silk moth 41, 42–43, 44
Sinea sp. 179
Skiff Slug 54
Slug caterpillar 52–53
Smaller Parasa 50
Snowberry Clearwing 31
Soifugae 226
Soldier fly 102–103
Sphingidae 38–39
Sphinx moth 38–39
Sphiximorpha willistonii 95
Spicebush Swallowtail 37
Spilomyia longicornis 99
Spiny Oak Slug 47
Spittle bug 184
Spotted Datana 19
Spreadwing damselfly 65
Square-headed wasp 86
Stalk-eyed fly 104
Stenacron sp. 228–229
Stephanidae 89
Stick grasshopper 141
Stick insect 154, 155, 165, 168
Stilt-legged fly 98
Stinging Rose Slug 48–49
Straight-snouted weevil 120–121
Striped Horse Fly 93
Sun spider 226
Symphyta 218–219
Synchlora aerata 28–29
Syrphid fly 95, 99, 105

T
Tabanus lineola 93
Tachinid fly 95, 96–97
Tailless whip scorpion 226
Tarantula 212–213
Tenodera aridifolia sinensis 169, 170–171

Tettigoniidae 142, 143
Theraphosidae 212–213
Thick-headed fly 105
Thorn treehopper 178
Tortoise beetles 122, 123, 124, 125, 126, 127, 128–129
Treehopper 185
Triepeolus sp. 82–83
Trychopeplus sp. 158–159
Tutelina elegans 208–209
Two-striped Walkingstick 161
Typophyllum sp. 136–137, 138

U
Umbonia crassicornis 178
Unidentified butterfly 26

V
Vates sp. 157

W
Walnut Sphinx 21
Wandering spider 199
Wasp mimic moth 32–33
Waved Sphinx 20
Wavy-lined Emerald Moth 28–29
White-dotted Prominent 25
White-streaked Prominent 45

X
Xysticus sp. 210

Y
Yellow-head soldier fly 90–91

Z
Zeta argillaceum 88
Zeugomantispa minuta 230, 231
Zygoptera 64, 66